HOPPER

Poetry

Dark Harbor 1993
The Continuous Life 1990
Selected Poems 1980
The Late Hour 1978
The Story of Our Lives 1973
Darker 1970
Reasons for Moving 1968
Sleeping with One Eye Open 1964

Prose

Mr. and Mrs. Baby 1985
The Monument 1978

Translations

Travelling in the Family 1986
(Poems by Carlos Drummond de Andrade,
with Thomas Colchie)
The Owl's Insomnia 1973
(Poems by Raphael Alberti)

Art Books

William Bailey 1987
Art of the Real 1983
Hopper 1994

For Children

The Planet of Lost Things 1982
The Night Book 1985
Rembrandt Takes a Walk 1986

Anthologies

Another Republic (with Charles Simic) 1976
New Poetry of Mexico (with Octavio Paz) 1970
The Contemporary American Poets 1969

HOPPER

..

Mark Strand

THE ECCO PRESS

The Ecco Press
100 West Broad Street
Hopewell, NJ 08525
Published simultaneously in Canada by
Penguin Books Canada Ltd., Ontario
Printed in the United States of America
Designed by Nick Mazella

First paperback edition, 1995

Library of Congress Cataloging-in-Publication Data

Strand, Mark, 1934–
 Hopper / Mark Strand. —1st ed.
 p. cm. — (Writers on art)
 1. Hopper, Edward, 1882–1967—Criticism and interpretation.
 I. Title. II. Series.
 ND237.H75S76 1993
 759.13—dc20 93-22165
 ISBN 0-88001-343-5
 ISBN 0-88001-395-8 paperback

The text of this book is set in Palatino.

to Judith and Leon

List of Illustrations

Preface

This book, short as it is, has been long in the making. Over twenty years ago, I wrote a piece for *The New York Times* on the paintings and drawings from the Hopper bequest on exhibit at the Whitney Museum. Years later, at the urging of Daniel Halpern, I wrote a short essay for *Antaeus* where I discussed certain formal properties shared by many Hopper paintings, and suggested that conventional views of Hopper as a painter of "loneliness" or "alienation" were inadequate. In 1991, while I was living in Washington, D.C., Hank Millen, the director of the National Gallery's Center for Advanced Study in the Visual Arts, asked if I would give a lecture there. The lecture, given in January 1992, was the first draft of *Hopper*. A year later, a second draft was presented at the Art Institute of Chicago. A few months after that, the third and final draft was submitted to The Ecco Press.

My purpose in writing about the paintings of Edward Hopper was not only to clarify my own thinking about them, but to correct what I perceived to be misconceptions advanced by other critics of his paintings. Much that had been written seemed to skirt the central issue of why vastly different people should be so similarly moved when confronted with his work. My approach to this and related issues has been largely aesthetic. I am less interested in the evidence of social forces in Hopper's work than I am in the presence of pictorial strategies. To be sure, his paintings represent a world that looks somewhat different from ours. However, the satisfactions and misgivings having to do with changes in American life during the

first half of the twentieth century cannot, by themselves, account for the strong response in most viewers. Hopper's paintings are not social documents, nor are they allegories of unhappiness or of other conditions that can be applied with equal imprecision to the psychological make-up of Americans. It is my contention that Hopper's paintings transcend the appearance of actuality and locate the viewer in a virtual space where the influence and availability of feeling predominate. My reading of that space is the subject of this book.

—M.S.

HOPPER

I

I OFTEN feel that the scenes in Edward Hopper paintings are scenes from my own past. It may be because I was a child in the 1940s and the world I saw was pretty much the one I see when I look at Hoppers today. It may be because the adult world that surrounded me seemed as remote as the one that flourishes in his work. But whatever the reasons, the fact remains that looking at Hopper is inextricably bound with what I saw in those days. The clothes, the houses, the streets and storefronts are the same. When I was a child what I saw of the world beyond my immediate neighborhood I saw from the backseat of my parents' car. It was a world glimpsed in passing. It was still. It had its own life and did not know or care that I happened by at a particular time. Like the world of Hopper's paintings, it did not return my gaze.

The observations that follow are not a nostalgic look at Hopper's work. They do, however, recognize the importance for him of roads and tracks, of passageways and temporary stopping places, or to put it generally, of travel. They recognize as well the repeated use of certain geometrical figures that bear directly on what the viewer's response is likely to be. And they recognize that the invitation to construct a narrative for each painting is also part of the experience of looking at Hopper. And this, inasmuch as it demands an involvement in particular paintings, indicates a resistance to having the viewer move on. These two imperatives—the one that urges us to continue and the other that compels us to stay—create a tension that is constant in Hopper's work.

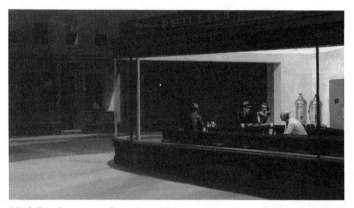

Nighthawks, 1942. Courtesy The Art Institute of Chicago, Friends of American Art Collection.

II

IN *NIGHTHAWKS*, three people are sitting in what must be an all-night diner. The diner is situated on a corner and is harshly lit. Though engaged in a task, an employee, dressed in white, looks up toward one of the customers. The customer, who is sitting next to a distracted woman, looks at the employee. Another customer, whose back is to us, looks in the general direction of the man and the woman. It is a scene one might have encountered forty or fifty years ago, walking late at night through New York City's Greenwich Village or, perhaps, through the heart of any city in the northeastern United States. There is nothing menacing about it, nothing that suggests danger is waiting around the corner. The diner's coolly lit interior

sheds overlapping densities of light on the adjacent sidewalk, giving it an aesthetic character. It is as if the light were a cleansing agent, for nowhere are there signs of urban filth. The city, as in most Hoppers, asserts itself formally rather than realistically. The dominant feature of the scene is the long window through which we see the diner. It covers two-thirds of the canvas, forming the geometrical shape of an isosceles trapezoid, which establishes the directional pull of the painting, toward a vanishing point that cannot be witnessed, but must be imagined. Our eye travels along the face of the glass, moving from right to left, urged on by the converging sides of the trapezoid, the green tile, the counter, the row of round stools that mimic our footsteps, and the yellow-white neon glare along the top. We are not drawn into the diner but are led alongside it. Like so many scenes we register in passing, its sudden, immediate clarity absorbs us, momentarily isolating us from everything else, and then releases us to continue on our way. In *Nighthawks*, however, we are not easily released. The long sides of the trapezoid slant toward each other but never join, leaving the viewer midway in their trajectory. The vanishing point, like the end of the viewer's journey or walk, is in an unreal and unrealizable place, somewhere off the canvas, out of the picture. The diner is an island of light distracting whoever might be walking by—in this case, ourselves—from journey's end. This distraction might be construed as salvation. For a vanishing point is not just where converging lines meet, it is also where we cease to be, the end of each of our individual journeys. Looking at *Nighthawks*, we are suspended between contradictory imperatives—one, governed by the trapezoid, that

urges us forward, and the other, governed by the image of a light place in a dark city, that urges us to stay.

Here, as in other Hopper paintings where streets and roads play an important part, no cars are shown. No one is there to share what we see, and no one has come before us. The scene of the picture belongs only to us. And what we experience will be entirely ours. The exclusions of travel, along with our own sense of loss and our passing absence, will flourish.

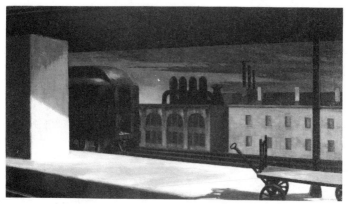

Dawn in Pennsylvania, 1942. Courtesy Terra Museum of American Art, Daniel J. Terra Collection.

III

PAINTED THE same year as *Nighthawks*, *Dawn in Pennsylvania* is also dominated by an isosceles trapezoid, one that, in this case, extends nearly across the full horizontal plane of the canvas. And the periodic posting of verticals that frame and give momentary respite in both paintings from the strong horizontal movement of the trapezoid are in almost identical positions and of the same size. But instead of looking into a diner, we look out toward a couple of industrial buildings from a covered station platform. And instead of walking somewhere, we are waiting to go somewhere. The feeling is that we will be waiting a long time. The large, squarish, off-white pillar breaks the forward thrust of the trapezoid, and the rear of a parked

railcar powerfully suggests that nothing in this station is moving. Unlike the complex *Nighthawks,* this painting turns on a simple paradox, which is that we feel trapped in a place whose purpose has to do with travel. The trapezoid—with some assistance from the tracks and the parked train—may suggest motion, but it is overwhelmed by the depth it encloses. That is, we look much further into *Dawn in Pennsylvania* than we do into *Nighthawks* and find ourselves looking through the trapezoid instead of being led by it. What we encounter is the cold and feeble light of a new day.

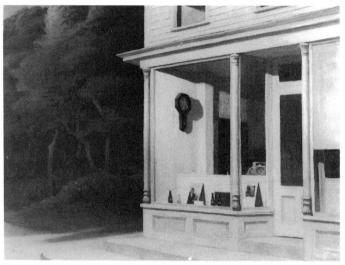

Seven A. M., 1948. Courtesy Whitney Musem of American Art, New York.

IV

THE STOREFRONT in *Seven A.M.* seems cheerful in its ordinary whiteness, its lack of clutter, its geometric certainty. And the trapezoid it forms is nowhere near as acute or extended, nor as troubling, as those that appear in *Dawn in Pennsylvania* and *Nighthawks.* Even though we are prevented from witnessing its resolution, we do not feel left behind or left out. For one thing, we seem to be in front of the store because we choose to be. There is no sense—as there is in *Nighthawks*—that we have just happened by. Nor is there a feeling of being imprisoned as

there is in *Dawn in Pennsylvania*. We may have approached for any number of reasons. Or no reason. It does not much matter. There is no urgency; there is only a geometric calm. And something else, something that the primness and tidiness of the storefront almost seems an attempt to hide—the massed trees, which form the dark, tangled, impenetrable presence of nature. They exist in the painting as a frightening alternative to the store, which manifests a set of orders, the most obvious of which is the temporal one symbolized by the centrally located clock, while the most civilized is the historical one represented by the engaged columns that flank the plate glass windows. Our position relative to the storefront is pretty much what it is in *Nighthawks* relative to the diner, but since the store is closed we are less drawn to what is inside, and we are more doubtful about the woods than we are about the city streets.

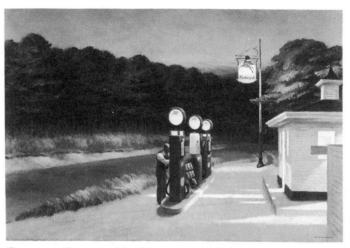

Gas, 1940. Courtesy The Museum of Modern Art, New York.

V

USUALLY WHEN woods appear in a Hopper they are across a
road or behind a house and do not reveal much of themselves.
In *Four Lane Road,* they are a blur, a hedge of trees; in *Gas,* they
are somewhat more defined, but not to the degree that the
buildings in Hopper's paintings are. With the exception of the
tamarack, Hopper's trees are generic. They look the way trees
do when we drive by them at fifty or sixty miles an hour. And
yet his woods have a peculiar and forceful identity. Compared
to the woods that precede them in American painting, they are
somber and uninviting. The wilderness of Cole, Church, and
Bierstadt was panoramic, open and available. It overwhelmed

but did not threaten. Its enhancements were inspirational, not fearful. It was a vast theater in which the moment of creation was enacted again and again. For Hopper, the wilderness is nature's dark side, heavy and brooding.

In *Gas* the shadowy woods seem poised, ready to absorb the viewer as well as whoever happens to be traveling down the road between them and the gas station. But they remain little more than an ominous backdrop to the small, futilely lit station and the station's attendant. It is the station, with its driveway lined with gas pumps on one side and a small white clapboard building on the other, that gathers our attention. It forms a corridor that leaves us little doubt as to where we —travelers and viewers alike—are headed. The illuminated

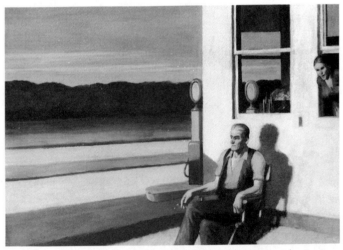

Four Lane Road, 1956. Private collection, printed by permission.

Mobilgas sign with its small, red, winged horse only under-
scores, with ironic detachment, the impossibility of our escap-
ing what seems like our mortal destiny. The presence of the
station's proprietor, who is still working, does nothing to dis-
pel our uneasy sense of what lies ahead. Even he is working
against time, staving off the night, extending the day.

Four Lane Road is a good deal less ominous than *Gas*. It
might even be thought humorous. The cigar-smoking station
owner is catching some sun while a woman, presumably his
wife, leans from the window to tell him something. That he
should get back to work? That lunch is ready? Something, at
any rate, that he feels he can ignore. She certainly isn't telling
him that she loves him, but even that, in the context of this
painting, might fall on deaf ears. The look of stupefied uncon-
cern on the man's face as he stares into space while his wife
tries to get his attention gives this painting a cartoonlike, anec-
dotal quality. The woods, meanwhile, appear uncharacteristi-
cally harmless in their background role.

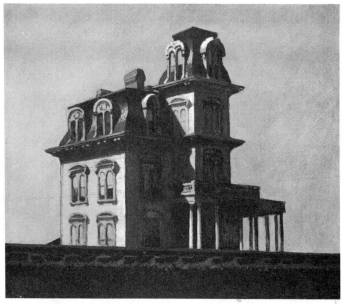

House by the Railroad, 1925. Courtesy The Museum of Modern Art, New York.

VI

HOUSE BY THE RAILROAD, with the exception of *Nighthawks*, is Hopper's most famous painting. It presents the sort of scene— an isolated house—that we might have passed at one time on our travels by train. The tracks suggest as much. But in this picture the tracks pass very close to the house. It may be that its owners were the victims of what we used to call "progress" and had to sell off land—in this case to the railroad. The house seems out of place yet self-possessed, even dignified, a sur-

vivor—at least for the time being. It stands in the sun but is inaccessible. Its hiddenness is illuminated but not revealed.

Standing apart, a relic of another time, the house is a piece of doomed architecture, a place with a history we cannot know. It has been passed by, and the grandeur of its containment doubles as an image of refusal. We cannot tell if it is inhabited or not. No doorway is visible. Its elaborate facade is still handsome, especially as the sunlight hits it, accenting its architectural details and lending the structure an overall solidity it probably would not actually have. And yet the light is not conventionally descriptive. The house shines with finality. It is like a coffin. It is beyond us, and so absolute in its posture of denial that attempts—and there have been many—to associate it with loneliness only trivialize it. Like other Hopper paintings we've looked at, this one makes use of geometrical properties. The familiar isosceles trapezoid is at work here as well. Formed by the tracks at the base and the cornice of the house at the top, it suggests movement to the left, toward the source of light, but in this instance only barely. The movement is counteracted by the strong verticality of the house, its stability and centrality. The house resists this pull, whether the temporal pull of light or the pull of progress or our own continuousness.

It may be that this harsh air of refusal is what makes *House by the Railroad* so popular. The house demands nothing from us, in fact, it seems to be turning away from wherever we are headed. It defines, with the simplest, most straightforward means, an attitude of resistance, of hierarchical disregard, and at the same time a dignified submission to the inevitable.

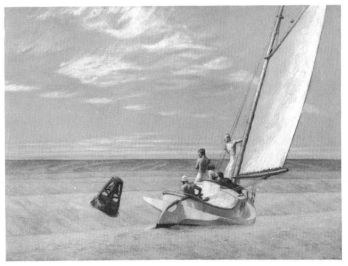

Ground Swell, 1939. Courtesy the Corcoran Gallery of Art.

VII

IN SOME Hoppers a refusal of the problematics of travel is attempted. One of the best-known of these is *Ground Swell*. It depicts a scene of unusual serenity. The sea has the undulant solidity of a rolling landscape, and the boat seems virtually motionless as it clears the bell buoy. But incongruous as the picture's stillness may be, it is not menacing. *Ground Swell* is under control. Its geometry is subtle. Two triangles intersect, each one canceling or stalling the motion of the other. The stronger and more dominant one runs the length of the sail, around the boat's foreshortened beam, to the buoy that points

back to the gaff which runs along the top of the sail; the other is formed by the cirrus clouds that arrange themselves into a giant V receding across the sky. But the triangle made by the boat and the buoy is the one that counts. It is what makes this picture so static and so much less mysterious than the others we have discussed. The boat and the buoy are locked together, immobilized by the figure they form. In addition, the people on deck, by staring at the buoy, help lock it in place. Their attention is not elsewhere, off canvas. Nor is it fragmented. It is concentrated on bridging the gap between the boat and the buoy. Everything in this painting suggests an equilibrium has been reached between the depiction of passage and the more powerful accommodation of stillness.

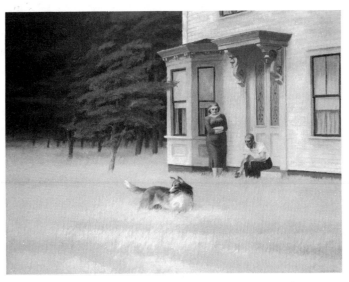

Cape Cod Evening, 1939. Courtesy National Gallery of Art, Washington, D.C., John Hay Whitney Collection.

VIII

IN *CAPE COD EVENING*, painted the same year as *Ground Swell*, the use of the triangle is more subtle in its narrative implications. Instead of being an instance of geometric insularity and safety set against the virtual emptiness of a deep space, it is a fragile and momentary arrangement of three figures set against the powerful claims of the familiar trapezoid. A woman watches while her husband tries to get the attention of their dog, whose gaze is fixed on something off canvas on the lower

left. The fact that the man's coaxing is not answered suggests that it is only a matter of time before the dissolution of the family, momentarily bound by focused attention, will occur. The trapezoid, which comes in from the right and is defined by the house's painted footing and the cornices above the door and the bay window, stops abruptly with the edge of the house halfway across the picture plane. But the movement it initiates is carried on, in a ragged way, by the woods, which dissolve into a foreboding darkness. The "evening," so matter-of-factly —even blandly—descriptive in the painting's title takes on a disturbing and powerful resonance. What at first seemed like a picture of unremarkable calm—a couple taking time out to play with their dog—is undermined by the impending dissolution of the structures in which they live. The house gives way to the woods, and domestic unity turns on the vagaries of a dog's attention.

IX

HOPPER'S PAINTINGS are short, isolated moments of figuration that suggest the tone of what will follow just as they carry forward the tone of what preceded them. The tone but not the content. The implication but not the evidence. They are saturated with suggestion. The more theatrical or staged they are, the more they urge us to wonder what will happen next; the more lifelike, the more they urge us to construct a narrative of what came before. They engage us when the idea of passage cannot be far from our minds—we are, after all, either approaching the canvas or moving away from it. Our time with the painting must include—if we are self-aware—what the painting reveals about the nature of continuousness. Hopper's paintings are not vacancies in a rich ongoingness. They are all that can be gleaned from a vacancy that is shaded not so much by the events of a life lived as by the time before life and the time after. The shadow of dark hangs over them, making whatever narratives we construct around them seem sentimental and beside the point.

X

WITHIN THE question of how much the scenes in Hopper are influenced by an imprisoning, or at least a limiting, dark is the issue of our temporal arrangements—what do we do with time and what does time do to us? In Hopper's paintings there is a lot of waiting going on. Hopper's people seem to have nothing to do. They are like characters whose parts have deserted them and now, trapped in the space of their waiting, must keep themselves company, with no clear place to go, no future.

Pennsylvania Coal Town, 1947. Courtesy Butler Institute of American Art, Ohio.

XI

IN *PENNSYLVANIA COAL TOWN* it is late in the afternoon. A man has come home from his job, taken off his jacket, and gone to rake the little plot of lawn that is presumably his. But in the middle of the raking, he looks up and stares into the space between his house and the house next to it. It is a space that forms a corridor of light. The moment of his looking up seems more than one of distraction. It has the feel of transcendence, as if some revelation were at hand, as if some transforming evidence were encoded in the light. There is some overall sym-

pathy in the way the fringe of grass at the edge of the plane on which the man stands is delicately highlighted, and the way the plant in the terra-cotta urn turns into a green plume. In what appears to be just another lower middle class neighborhood, something is taking place that cannot be accounted for conventionally. It is like an annunciation. The air is stricken with purity. And we are involved in a vision whose source is beyond us, and whose effect is difficult to embrace. After all, we view the scene from the shade. And all we can do from where we stand is meditate on the unspoken barriers between us. For an instant, we are drawn to the man in the painting, are drawn to what the painting never reveals about what he sees. And we are made to feel that our separation is appropriate, that whatever the true character of the light, whatever its significance, it is for the man alone to experience. We can only observe his moment of privilege from a respectful distance.

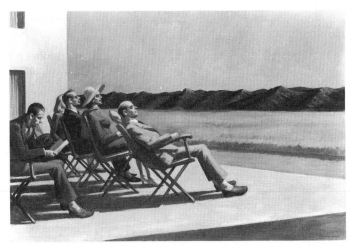

People in the Sun, 1960. Courtesy National Museum of Art/ Smithsonian Institution.

XII

PEOPLE IN THE SUN is very much the opposite of *Pennsylvania Coal Town*, but no less a mystery. It is a mixture of the comic and the forlorn. A small group of people, whose chairs are lined up, sit in the sun. But are they there to get sun? If they are, why are they dressed for work, or as if they were in a doctor's waiting room? Maybe they wait wherever they are, and the world is their waiting room? Maybe. And what are we to make of the young man reading, who sits behind the file of four? He appears to be more absorbed in culture than in nature, yet he is out there with the others, by the road, in the sun.

The light is peculiar. It falls on the figures but does not fill the air. In fact, one of the peculiarities of Hopper's light is that it has so little to do with atmosphere in the way, for example, light in impressionist painting does. One cannot imagine these people are getting much sun. They seem rather to be looking ahead, so far as we can tell, into a wide field that extends to a row of hills. And the hills, because they rise at pretty much the same angle as the people assume in their seated postures, seem to be looking back. Nature and civilization almost appear to be staring each other down. So odd is this painting that I sometimes think the seated figures are looking at a painting of a landscape, and not a real one, which of course they are.

XIII

I HAVE said that Hopper's light is peculiar, that it does not seem to fill the air. Instead, it seems to adhere to walls and objects, almost as if it comes from them, emanating from their carefully conceived and distributed tones. (By tones I mean the combined effect of hue with light and dark.) My friend, the painter William Bailey, once said that Hopper's shapes carry the sensation of light, and I think his statement is true. In Hopper's paintings, light is not applied to shape; rather, his paintings are built from the shapes that light assumes. His light, especially his interior light, can be convincing without ever being fluid. It is the opposite of Monet's light, which, in its vast dishevelment and feverish spread, wants to dematerialize everything. Just think how Monet's light turns the great facade of the Rouen Cathedral into an airy wedding cake or the heavy stone of Waterloo Bridge into a bluish violet mist.

One of the reasons Hopper's light is so wedded to objects is that his paintings were, by his own admission, put together from notes and memory. And our memory of objects and their deployment is apt to be much firmer than our memory of air or light, just as our memories of interiors is likely to be more accurate than our memory of exteriors. To capture light, so to speak, one must go outside and paint, which Hopper did not do when he worked in oil. Actual light changes too quickly for a man who worked as slowly as Hopper did. He had to imagine a light to go with his world of fading particulars, and this was best done in the studio. His paintings are careful and scrupulously considered rather than improvisational, and their

light has a memorial rather than celebratory character. Hopper's attempts to fix it, to give it a life that would resist dissolution, may account for the geometrical severity of its shapes. But such a light can only remind us of what it resists and can be little more than a respite from the more powerful claims of darkness.

The influence of the light from nineteenth-century American painting on Hopper is actually small. Sometimes we see traces of luminism—a kind of painting that flourished in the 1850s and included Heade, Kensett, and Church among its adherents—in those paintings where objects are caught in a magical stillness and are seen with disarming clarity. But luminist light is temporal—always a moment and no more, always a crystalline instant in which the look of nature assumes the force of its purpose, and in which a mortal glow is imparted to everything. Whereas Hopper's light, despite the titles of his paintings, is atemporal.

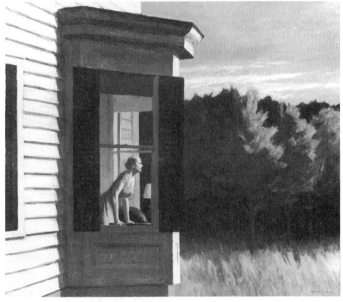

Cape Cod Morning, 1950. Courtesy National Museum of Art/
Smithsonian Institution.

XIV

WHEN I wrote about *Pennsylvania Coal Town* (1950), I described
its light as annunciatory. What I meant is that its light seems to
have an otherworldly power, that it seems to bear some mes-
sage whose meaning, if it is revealed at all, is intended only for
those upon whom it falls. In this way it is exclusive. *Cape Cod
Morning* and *Morning Sun* (1952) are two paintings in which
this feature of Hopper's light is quickly discernible.

In *Cape Cod Morning* a woman in a pink dress stares from a bay window toward the light. She leans forward expectantly. Yet we cannot tell what she is looking at or if in fact she is looking at anything. The object of her attention, like the source of the light, is beyond the picture. We can witness only its effects, how the woman's pose manifests her attraction to it. In Hopper it seems there is always something "beyond" that works its influence on those within the picture. It might even be an idea of limitation, akin to the kinds of limitation that the traveler experiences. Or so it seems to those of us on the outside.

The woman in *Morning Sun*, who looks almost exactly like the woman in *Cape Cod Morning*, wears a shift of the same color and also wears her blondish hair drawn straight back from her

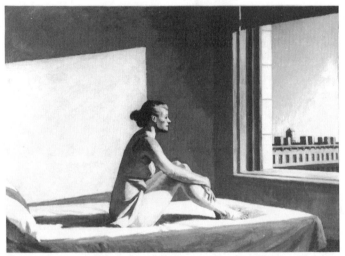

Morning Sun, 1952. Courtesy Columbus Museum of Art, Ohio.

face. She sits up in bed, staring through a large window at the city. She, too, is a recipient of the sun's warmth. She, too, seems fixed on something beyond the painting's realm. And more than the other woman, or any of Hopper's figures perhaps, she seems sculpted by the light. She does not suffer the slight disfigurement or coarsening that other Hopper women do, whether as a result of what the light does or by the way the paint is applied.

The woman who stands and smokes a cigarette on a carpet of light beside an unmade bed in *A Woman in the Sun* is a different story. Though she receives the light, she does so with less apparent eagerness. She appears thoughtful. The light coats the front of her. And the parts of her it does not touch fall abruptly

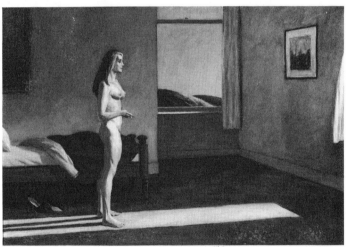

A Woman in the Sun, 1961. Courtesy Whitney Musem of American Art, New York.

into shadow. There is no softening, no gradual rounding of her form. Rather, a jagged edge of light lingers on her sinewy, masculine body. What Hopper had to do as an illustrator—idealize the figure—he chose not to do as a painter. His women are no more beautiful than the paintings themselves and belong entirely to the formal imperatives that have given them their existence. The woman in *A Woman in the Sun* may not fit anyone's notion of beauty, but she is nevertheless magnificently present, charging the room with a gloomy, wistful eros. Obviously enjoying a moment of introspection, she stands, with her legs slightly apart, availing herself of the sun's warmth and the refreshment of a breeze that comes in the window. One feels that the first thing she was moved to do upon waking was to appease the flesh, but one also feels that her momentary indulgence is compensatory. That she is not a woman who padded about in her "jammies" and slippers before nodding off is obvious. The high-heeled pumps beside the bed suggest that she retired with haste. It is pointless, however, to speculate further on what her present pensiveness has to do with or what preceded her falling to sleep. Her past, like the back of her body, is left in shadow.

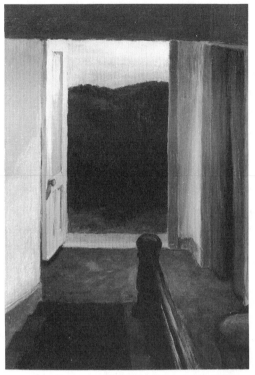

Stairway, c. 1919. Courtesy Whitney Museum of American Art, New York.

XV

So MUCH of what occurs within a Hopper seems related to something in the invisible realm beyond its borders: figures lean toward an absent sun, roads and tracks continue toward a

vanishing point that can only be supposed. Yet Hopper often establishes the unreachable within his paintings.

In *Stairway*, a small, eerie picture, we look down some stairs through an open door to a dark, impenetrable massing of trees or hills directly outside. Everything in the house says, Go. Everything outside says, Where? All that the painting's geometry primes us for is darkly denied us. The open door is not the innocent passage connecting inside and outside but a gesture paradoxically designed to keep us where we are.

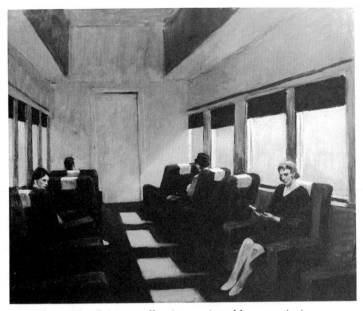

Chair Car, 1965. Private collection, printed by permission

XVI

IN *CHAIR CAR,* a progression of yellow blocks of light on the train car floor, flanked by windows and chairs, leads to the end of the car, which seems not only large but stripped of features we associate with railcars—notably, an overhead rack for luggage and a handle or window on the door. The high ceiling, which is unusually squarish instead of tapered, and the closed door have the effect of establishing an absolute barrier to our forward motion and creating the strong impression that if the

people here are traveling, they are not going far. Nor is there anything outside the windows to suggest motion, nothing but the light, which, though it leads the viewer to the door, seems to immobilize the painting, freezing it in an absolute present. This is another example of the occluded vanishing point. We are led down the aisle and denied continued progress, or the satisfaction of doing what we have been led to expect. This painting's equivalent of the clump of trees in *Stairway* is the missing handle on the door.

One of the charming features of *Chair Car* is the way the four passengers display a randomness of individual concerns. One reads, another stares at the one who reads, another's head is tilted to the right, another's to the left. In some way, the inwardness of each seems to intersect the main thrust of the painting, freeing them from the imprisoning character of the car. The sensation of being both locked in and locked out at once is closely related to what we experience in *Nighthawks*, which urges us forward while insisting that we stay. It is a fairly consistent pattern in Hopper that a pictorial geometry should demand an action contrary to what the narrative wills.

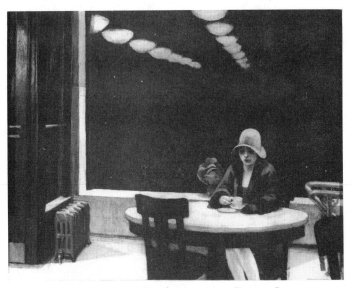

Automat, 1927. Courtesy Des Moines Art Center, Iowa.

XVII

IN *AUTOMAT* a woman, near a door and in front of a plate glass window, sits alone at a round table. One hand rests on the table and is gloved, the other is bare and holds a cup of coffee. The woman is pensive. If we could know her thoughts, they would no doubt provide the narrative for this painting. But the painting itself provides the viewer with an indication of what the woman might be thinking. The window reflects only the twin receding rows of ceiling lights and nothing else of the automat interior. It allows nothing of the street, or whatever is outside,

to be seen. The painting suggests several things, but the most obvious and most resonant is that if what the window reflects is true then the scene takes place in limbo and the seated woman is an illusion. This is a troubling idea. And if the woman thinks of herself in this context, she cannot possibly be happy. But of course she does not think, she is the product of another will, an illusion, an invention of Hopper's.

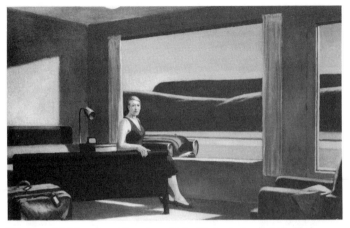

Western Motel, 1957. Courtesy Yale University Art Gallery.

XVIII

THIRTY YEARS after *Automat*, Hopper painted *Western Motel*. A woman stares out at the viewer—the only one of Hopper's people to do so—as if her photo were about to be taken. She exhibits none of the inwardness or uncertainty of the young woman in *Automat*. There is no hint that profound questions are being asked. The woman poses a little stiffly, as if she were anxious to unpack or pull the curtain or do anything but what she is doing. She sits near the end of the bed and to the side of the large picture window, allowing the photographer to include some of the scenery, barren though it may be, and the highway, and the front end of her car—a green Buick. The sudden immobility of the woman, the attention she gives

the photographer—from whose vantage point we see her—shuts down the heavy traffic of horizontals. An amazing stillness is forged by the acknowledged presence of another. It is particularly witty that the painter and the viewer should combine forces to play the role of photographer. We are the real reason everything seems to stop in the picture. We are the invisible force within the painting, and we are the occasion it honors. This may be the reason we do not feel excluded. We are not being urged on. The moment is ours. We are stilled even within the stillness of our break from travel.

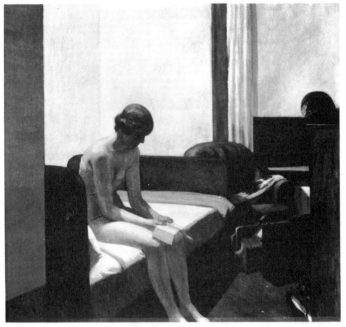

Hotel Room, 1931. Courtesy Thysen-Bornemisza Collection.

XIX

THE WAY the woman in *Hotel Room* is sitting on the edge of the bed, slightly hunched over, the way she holds the letter with her hands resting on her knees, suggests that she has read the letter many times and the news it brings is not good. The "feel" of this painting is similar to that evoked by *Automat*. If the woman in *Automat* held a letter instead of a coffee cup, she

might be the same woman, only several years younger. The cramped neatness of the room, the merciless white of the illuminated walls, the crisp verticals and horizontals provide a pleasant severity that contains the traveler as she deals with what she reads—probably some news that calls for containment. Indeed, the room seems like a substitute for the woman's resignation. This painting is very much the opposite of *Western Motel*, which seems to invite, with its openness, its horizontal spread, its view. In *Hotel Room* we are led down a minimal corridor, formed by the length of the bed and the side of the bureau, and crowded with luggage and shoes, to the chilling opacity of the night. It is astonishing how quickly we are drawn from the seated woman to the window and what it reveals of the outside or the beyond or even the future—nothing but a black square, an irreducible conclusion, a place for a vanishing point.

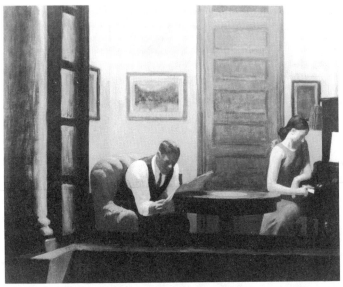

Room in New York, 1932. Courtesy Sheldon Memorial Art Gallery, Hall Collection, University of Nebraska–Lincoln.

XX

ROOM IN NEW YORK is another of those scenes one might encounter on a walk in the city or see from one's apartment. A couple sit in their living room. He leans forward and reads the paper. She sits across the small room, looking down as she touches the piano keys with one finger. It is a scene of domestic calm in which a man and a woman are absorbed in their own thoughts and appear at ease within the confinement of their small apartment. But are they at ease? The man is intently

reading, but the woman is not intently playing the piano. She is idling away time, presumably until her husband is through with the paper. It is one of those in-between moments that are more common and more characteristic of our lives than we care to acknowledge. This of all Hopper's paintings is the most reminiscent of Vermeer, especially of his *A Lady Writing a Letter with Her Maid*. The lady writes, and the maid, like the wife in *Room in New York*, waits. The disposition of objects, the kind of light, the placement of people, differ considerably, and so does the fact that one is seen through a window and the other from an undetermined but omniscient point of view. But they are alike in their suggestion that one's separateness can flourish in the company of another. The man and the woman in *Room in New York* are both joined and apart, just as the boat and buoy are in *Ground Swell*. But here something is said about the habit of estrangement, that it not only exists among couples, it flourishes calmly, even beautifully, among them. The man and the woman are caught, fixed in a sad equilibrium. Our gaze is directed not at either one, but right up the middle between them, right to the door, which is shut not on either one but on both together.

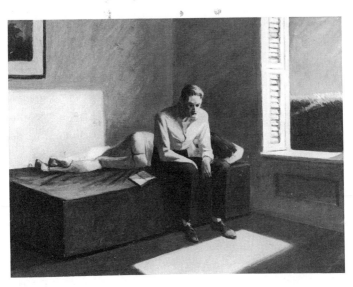

Excursion into Philosophy, 1959. Private collection, printed by permission.

XXI

In *Excursion into Philosophy*, a man, obviously troubled, sits at the edge of a daybed on which a woman with bare buttocks and legs lies with her back to him. Light from an open window has imprinted itself on the floor at the man's feet and on the wall behind the bed. A book lies open beside the man. Clearly there is a story here, but unlike most of the paintings I have discussed, it is not a story accomplished by the shrewd disposition of formal or abstract elements. Here the burden of

meaning falls on the man, the woman, and the book, and to read the painting we must construct a narrative of their relationship to each other. Is the woman tired of the man? Is the man tired of the book? Was the book supposed to supply something the woman couldn't? In no time we leave the painting behind and are involved in the banality of a melodrama, which depends, unfortunately, on the look of disillusionment that is writ large on the man's face. But perhaps his look of exaggerated concern is needed to convey what the placid, self-contained character of the rest of the painting cannot. Unlike *Nighthawks, Excursion into Philosophy* does not sway its viewers to feelings of isolation or exclusion. It invites us into its static center where the man, the woman, and the book are gathered in an odd triangulation of forces.

What about the book? What about the painting's title? Mrs. Hopper, a critic tells us, once commented that "the open book is Plato, reread too late." Another critic reports that it was Hopper himself who remarked of the man that "he has been reading Plato rather late in life." I personally can't see the harm of reading or rereading Plato late in life. I can't see what harm Plato could do at any stage of one's life. But perhaps too much is being made of Plato. His name might have been the first to come to Hopper's mind. For even people who don't read philosophy will have heard of Plato. And perhaps the tone with which Plato was mentioned was offhand, humorous, or deliberately misleading. After all, the painting is not called *Excursion into Plato* or *The Limitations of Plato* or *Postcoital Sadness and Platonism.* It is a weakness of the painting that the burden of meaning relies solely on narrative figuration. It becomes a car-

toon, a hopelessly reductive view—of what? The life of the mind versus the life of the body? The spiritual versus the physical? The man's crudely furrowed brow seems more and more like a bit of overacting, and the woman's coarsely depicted buttocks a joke.

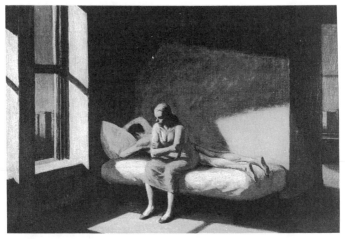

Summer in the City, 1949. Private collection.

XXII

IN *SUMMER IN THE CITY,* a woman sits pensively at the edge of
a bed on which a naked man lies with his face buried in a pil-
low. This painting is very much like *Excursion into Philosophy*
except that the man and the woman have reversed roles. Here,
too, we are drawn to search for a clarifying narrative. But there
is a poignancy about this painting that is absent from the other,
perhaps because we sense that a personal drama is being
played out within a context that is far from neutral. For the
painting suggests that whatever the problem the couple is hav-

ing, there will be no happy escape from it. The light entering the room to surround the couple, even seeming to close in on them, the view of the city bracketing the painting on either side, the overall barrenness of the apartment—all suggest imprisonment. It is a scene whose troubling content we cannot know. We know only that it bears the burden of an accusing light and that the couple will be free of their mortal misery only when darkness falls.

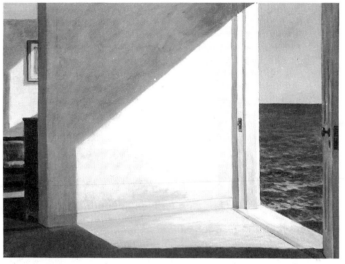

Rooms by the Sea, 1951. Courtesy Yale University Art Gallery.

XXIII

ROOMS BY THE SEA and *Sun in an Empty Room* seem, at first glance, to be similar: interiors without people, walls blazoned with chunks of sunlight. But the austerity of *Rooms by the Sea* is much more congenial than that of *Sun in an Empty Room*. A cheerful strangeness occupies its spaces. The view that fills the open doorway on the right, though stark, is not forbidding. The water seems to come right up to the door, as if there were no middle ground or shore, as if, in fact, it had been stolen from Magritte. It is a view of nature, unembellished and extreme. On the left side of the painting is a narrow, crowded view of

nature's opposite—a room furnished with a couch or chair, a bureau, and a painting—the selected accoutrements of domestic life. The picture urges us to move from right to left, as if the view it wished to offer us were not of the sea but of the partially hidden second room. Even the sea seems to be looking up and in, and the light seems to be pointing, telling us which way to look.

We do not feel, as we do in other Hoppers, that an instant has been frozen, that it has assumed the monumental shape of a geometrical figure. Instead, we feel something like its extension as it accommodates the duration of our looking. For by moving across the picture plane we move more deeply within it. The second room is a furnished echo of the first. The doubling of the space is comforting since it enacts ideas of continuation and connection, both basic to domestic well-being. And the sea and sky, double agents of nature's will, look harmless in this context.

Sun in an Empty Room, 1963. Private collection, printed by permission.

XXIV

IN THE later painting, *Sun in an Empty Room,* there is nothing calming about the light. It comes in a window and falls twice in the same room—on a wall close to the window and on a slightly recessed wall. That is all the action there is. We do not travel the same distance—actual or metaphorical—that we do in *Rooms by the Sea.* The light strikes two places at once, and we feel its terminal character instead of anything that hints of continuation. If it suggests a rhythm, it is a rhythm cut short. The room seems cropped, as if the foreground were cut away.

What we have is a window wall, with the window framing the highlighted leaves of a nearby tree, and a back wall, a finality against which two tomblike parallelograms of light stand upright. Done in 1963, it is Hopper's last great painting, a vision of the world without us; not merely a place that excludes us, but a place emptied of us. The light, now a faded yellow against sepia-toned walls, seems to be enacting the last stages of its transience, its own stark narrative coming to a close.

XXV

In Hopper's paintings we can stare at the most familiar scenes and feel that they are essentially remote, even unknown. People look into space. They seem to be elsewhere, lost in a secrecy the paintings cannot disclose and we cannot guess at. It is as if we were spectators at an event we were unable to name. We feel the presence of what is hidden, of what surely exists but is not revealed. By formalizing privacy, by giving it a space where it can be witnessed without being violated, Hopper's power over us is exercised with utmost tact. We encounter the reticence of his paintings with our own, and our sympathy increases. Hopper's rooms become sad havens of desire. We want to know more about what goes on in them, but of course we cannot. The silence that accompanies our viewing seems to increase. It is unsettling. We want to move on. And something is urging us to, even as something else compels us to stay. It weighs on us like solitude. Our distance from everything grows.

Acknowledgments

Nighthawks, 1942. Oil on canvas, 76.2 x 144 cm. Friends of American Art Collection, 1942.51.

Dawn in Pennsylvania, 1942. Oil on canvas, 24⅜ x 44¼ inches. Daniel J. Terra Collection, 18.1986. Courtesy of Terra Museum of American Art, Chicago, © All rights reserved.

Seven A.M., 1948. Oil on canvas, 30 x 40 inches. Collection of Whitney Museum of American Art. Purchase and exchange 50.8.

Gas, 1940. Oil on canvas, 26¼ x 40¼ inches. The Museum of Modern Art, New York. Mrs. Simon Guggenheim Fund.

House by the Railroad, 1925. Oil on canvas, 24 x 29 inches. The Museum of Modern Art, New York. © All rights reserved.

Ground Swell, 1939. Oil on canvas, 36½ x 50¼ inches. In the Collection of the Corcoran Gallery of Art, Museum Purchase, William A. Clark Fund.

Cape Cod Evening, 1939. Oil on canvas, 30¼ x 40¼ inches; framed: 42 x 52 inches. John Hay Whitney Collection, © 1993 National Gallery of Art, Washington.

Pennsylvania Coal Town, 1947. Butler Institute of American Art, Youngston, Ohio.

People in the Sun, 1960. Oil on canvas, 40⅜ x 60⅜ inches. 1969.47.61. National Museum of American Art, Smithsonian Institution. Gift of S. C. Johnson & Son, Inc.

Cape Cod Morning, 1950. Oil on canvas, 34⅛ x 40¼ inches. 1986.6.92. National Museum of American Art, Smithsonian Institution. Gift of the Sara Roby Foundation.

Morning Sun, 1952. Oil on canvas, 28½ x 40⅛ inches. Columbus Museum of Art, Ohio. Museum Pruchase Howald Fund.

A Woman in the Sun, 1961. Oil on canvas, 40 x 60 inches. Collection of Whitney Musem of American Art. 50th Anniversary Gift of Mr. and Mrs. Albert Hackett in honor of Edith and Lloyd Goodrich.

Stairway, c.1919. Oil on wood, 16 x 11⅞ inches. Collection of Whitney Musem of American Art. Josephine M. Hopper Bequest 70.1265.

Automat, 1927. Oil on canvas, 28¼ x 36 inches. Des Moines Art Center Permanent Collection, 1958.2.

Western Motel, 1957. Oil on canvas, 30¼ x 50⅛ inches. Yale University Art Gallery. Bequest of Stephen Carlton Clark, B.A. 1903.

Hotel Room, 1931. Oil on canvas, 152.4 x 165.7 cm. Thyssen-Bornemisza Collection, Lugano, Switzerland.

Room in New York, 1932. Oil on canvas, , 29 x 36 inches. UNL-F.M. Hall Collection, Sheldon Memorial Art Gallery, University of Nebraska–Lincoln. 1936.H-166.

Rooms by the Sea, 1951. Oil on canvas, , 29 x 40⅛ inches. Yale University Art Gallery. Bequest of Stephen Carlton Clark, B.A. 1903.

About the Author

Mark Strand was born in Summerside, Prince Edward Island, Canada, and was raised and educated in the United States and South America. He is the author of eight books of poems, the most recent of which is *Dark Harbor*, published in 1993. His book of short stories, *Mr. and Mrs. Baby* was published in 1985. His translations include *The Owl's Insomnia*, a selection of Rafael Alberti's poems, and *Travelling in the Family*, a selection of Carlos Drummond de Andrade's poems, edited in collaboration with Thomas Colchie. He has written several children's books, and edited several anthologies, including *Another Republic*, which he co-edited with Charles Simic. He has published numerous articles and essays on painting and photography, and in 1987 his book on William Bailey was published. He has been the recipient of fellowships from the Ingram Merrill, Rockefeller and Guggenheim Foundations and from the National Endowment for the Arts. In 1979 he was awarded the Fellowship of the Academy of American Poets, and in 1987 he recieved a John D. and Catherine T. MacArthur Fellowship. In 1990 he was chosen by the Librarian of Congress to be Poet Laureate of the United States. He lives in Baltimore with his wife and son.